oil

English translation © Copyright 1997
by Barron's Educational Series, Inc.
Original title of the book in Spanish is *Para empezar a pintar Óleo*
© Copyright Parramón Ediciones, S.A. 1996—World Rights
Published by Parramón Ediciones, S.A., Barcelona, Spain

Author: Parramón's Editorial Team
Illustrator: Parramón's Editorial Team

All inquiries should be addressed to:
Barron's Educational Series, Inc.
250 Wireless Boulevard
Hauppauge, New York 11788

Library of Congress Catalog Card No. 97-9415

International Standard Book No. 0-7641-0239-7

Library of Congress Cataloging-in-Publication Data
Para empezar a pintar óleo. English
 Learning to paint in oil / [author, Parramón's Editorial Team;
illustrator, Parramón's Editorial Team].
 p. cm. — (Barron's art guides)
 ISBN 0-7641-0239-7
 1. Painting—Technique. I. Parramón Ediciones. Editorial
Team. II. Title. III. Series.
 ND1473.P3713 1997
 751.45—dc21 97-9415
 CIP

Printed in Spain
98765

BARRON'S ART GUIDES
LEARNING TO
PAINT IN
oil

Contents

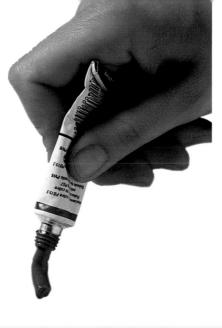

The versatility of oil paint makes it a highly attractive and motivating medium for artistic expression. The possibility of working with opaque impastos or thin transparent glazes or of producing a painting with either a glossy or a matte finish are just a few examples of why oil is the most popular medium.

But all the expressive possibilities of oil painting have their tricks and secrets, especially for the beginner who has yet to master the techniques of the medium. This book will provide such knowledge for those who are attracted to the oil medium but lack the fundamentals. It will show you the materials required and provide detailed explanations of all aspects of oil painting from purchasing a tube of paint to applying it to the canvas.

You will quickly discover how the fascinating medium of oil allows you to invent and create new techniques for yourself. Despite this, it is important to bear in mind that the oil technique cannot be learned in a day and that only with patience and constant practice will you eventually reach your goal. Remember that on taking your first steps in oil painting you are sowing seeds that are certain to yield a successful harvest in the future.

Paint

Oil paint is basically composed of pigment and oil medium. It has a creamy consistency, which enables the artist to apply it either in thick or thin layers, making it highly versatile and easy to work with.

Composition of Paint

Oil paint is made up of pigments bound together with oil, and its main solvent is turpentine.

The pigment is composed of tiny mineral or organic particles of color. The most common oils employed in the manufacture of oil paints have a high degree of transparency and form tough adhesive films when they dry. Among them are linseed oil, walnut, poppyseed oil, and the oil from crocus or soy bean. Turpentine is used to dilute the oil, thus making it thinner.

The manufacture of oil paint consists of macerating (soaking the dry pigment in oil), mixing the dry pigment with the oil medium, and grinding the two together into a homogeneous paste.

Oil paints offer a wide range of possibilities and allow various applications from painting with thick layers of color to applying glazes that permit the underlying layers to remain visible through subsequent transparent brushwork.

What You Can Buy

Oil paints are mainly sold in a creamy state in tubes, jars, and cans, and they are also sold in stick form.

Oil.

Turpentine.

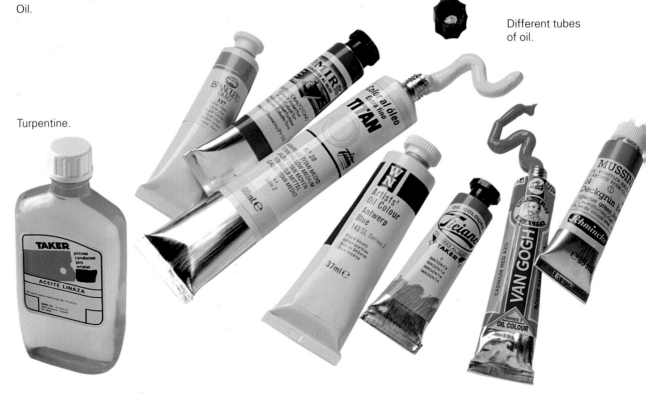

Different tubes of oil.

Qualities

It is important to work with good quality paints because their ingredients guarantee a better result and drying without color alterations. The brushwork effected with high-quality oil paint is much better than that made with an inferior type.

There are three paint qualities to choose from: "student paint," medium quality, and professional. The amateur painter should avoid those in the student category because although they are economical the end result is disappointing. Therefore, it is always better to work with medium-quality or professional colors.

TUBES

Most oil colors are sold in tubes. Since you will be using many colors, tubes are preferred because they meet the needs of both amateurs and professionals alike.

Tubes of oil paints come in different sizes and qualities and can be purchased separately or in sets.

USES: Tubes are easy to store and their paints are less likely to dry up. Furthermore, the oil paint can be extracted without making a mess.

ADVANTAGES: Oil colors in tubes are not messy to handle and no special tools are required to extract the paint from the tubes. In addition, they can easily be stored and transported in a paint box, and their color contents are easy to distinguish from their packaging.

DISADVANTAGES: Once the paint has been squeezed out of the tube it cannot be put back; therefore, it is advisable to extract only the amount needed.

JARS

Jars are designed for professionals and amateurs who require larger amounts of paint. Oil paints are sold in 500-ml jars, with a screw-on lid to prevent the paint from drying up. We only recommend jars for those painters who use large amounts of paint. Not all brands offer 500-ml jars, but those that do also offer good quality paint in other quantities too.

USES: Because jars typically contain more paint than tubes, the painter can work without continuous visits to the art supply store to buy more paint.

ADVANTAGES: Clean, unused paint can be returned to the jar with a palette knife.

DISADVANTAGES: Once a jar is opened and air comes into contact with the paint, the paint will dry more quickly than that contained in tubes. In addition, jars require more storage space and are not easy to transport.

Oil paint in a jar.

OIL STICKS

Oil sticks can be used to paint directly without the use of a brush. They come wrapped in paper as well as a film, or skin, that must be removed before use.

USES: The oil stick can be applied directly to the support and is fully compatible with oil paints from tubes.

ADVANTAGES: The main advantage of the oil stick is that it can be used as a drawing instrument, while at the same time allowing the artist to create impastos.

DISADVANTAGES: They can be somewhat bothersome to use because the paper covering their surface has to be continuously peeled back. Furthermore, they are messier to use than oil colors from tubes, and when stored together, the different colors tend to stain one another.

If the cap becomes difficult to open, carefully heat it with a cigarette lighter. This will loosen the dried up paint and make the cap easier to unscrew.

Oil sticks.

REMEMBER . . .

■ Oil is a greasy paint and its stains are difficult to remove, so it is advisable to wear suitable clothing when painting.

■ There are hundreds of good paint brands on the market, each of which has a wide range of different quality products. Therefore, don't stick to one particular brand; your work will benefit from experimenting with a variety of products.

Supports

Any type of support can be used for oil painting, provided it has been prepared for this purpose. The most common type of support for oil painting is canvas, but wood or cardboard can also be used. Each support lends the oil medium its own special characteristics.

Unprimed Canvases

An unprimed surface is one that contains no additive or protective layer, in other words, it is the canvas in its natural state. Because the oil must never come into direct contact with the canvas, it is always primed with a layer of priming or sealer.

Canvas, that is made of woven thread, is the most resistant and lightest support available for painting. The quality of a canvas depends on how it is woven; closely woven canvas leaves little space between each thread. The thickness of the canvas is therefore determined by how thickly woven the strands are.

Canvas can be woven from threads of organic origin, the most common of which are cotton, linen, and hemp. Canvas used for painting must have certain characteristics for the paint to remain stable after it has dried. Therefore, once the canvas has been stretched, its elasticity should not change. The best quality canvases are made of linen and can be primed with either gesso made with rabbit skin glue or acrylic.

Primed Canvases

A priming is a protective layer that is used to protect the support from direct contact with the oil paint.

Canvas supports can be bought primed or unprimed, but it is always advisable to buy them with a suitable priming for oil painting. Although they can be primed at home, art supply stores sell high-quality primed canvases. Most primers are either made of acrylic, plastic, or gesso made with rabbit skin glue. Acrylic and plastic primers are more elastic and secure so they don't become brittle with age. Priming with gesso made with rabbit skin glue is highly stable but laborious and will crack if not applied correctly.

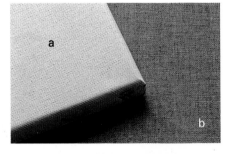

A primed linen canvas (a) and unprimed one (b).

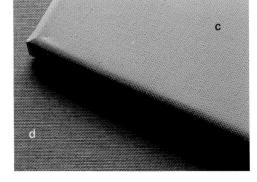

A primed cotton canvas (c) and an unprimed one (d). The cotton canvas is of a lower quality than the linen type; nonetheless, once primed, its surface is ideal for oil. The price difference between linen and cotton makes cotton more recommendable for the amateur.

Texture

The texture or grain of canvas may be fine, medium, or coarse. The choice of which type to use depends on the kind of picture you want to paint. If you are going to include many fine details you should choose a fine canvas. If you are doing more expressionistic work, you should select a medium or coarse textured canvas.

Quality and Recommendations

The best canvases are made of linen, although they are not recommended for beginners because they are more costly. A suitable substitute is good quality cotton canvas. Canvases that are made up of a mix of synthetic fibers, cotton, and linen are also available.

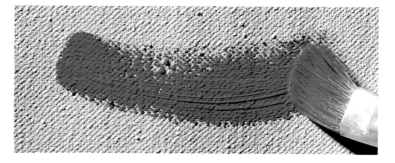

A brushstroke on a coarse-textured canvas.

Rigid Supports

Masonite, plywood, and canvas boards or panels are the most commonly used rigid supports for oil painting, but like canvas, they must be primed to prevent the oil from coming into direct contact with the surface of the support.

Several types of canvas-covered cardboard—called canvas boards or canvas panels—are available at a reasonable price. Plywood and masonite can be purchased in different sizes both in hardware stores and in certain art supply stores. Oil paint can also be applied on cardboard and on special paper that comes in a pad and whose appearance is similar to canvas.

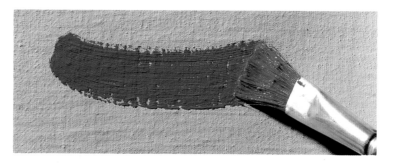

A brushstroke on a fine-textured canvas.

Stretchers

As the name suggests, stretchers are used to stretch and support the canvas. They are sold in many internationally recognized sizes, which are divided into three formats: figure, landscape, and seascape. The most elongated of the three is the seascape, while the most commonly used formats are the landscape and the figure.

Stretchers may have mitered or straight joints. The former type is known as a *French* or *European stretcher*; the latter, a *Spanish stretcher*. The best quality stretcher is the Spanish type, whose joints fit perfectly together to create a stable frame.

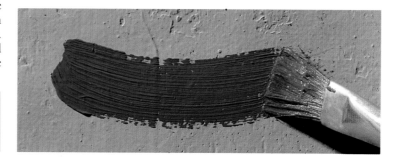

A brushstroke on a canvas primed with acrylic.

1. Special paper for oil painting.
2. Canvas board.
3. Unprimed cardboard.
4. Unprimed plywood board.

1. French or European stretcher.
2. Spanish stretcher.

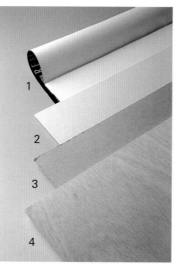

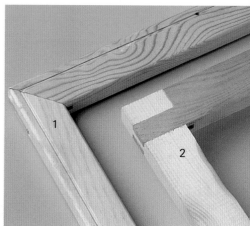

REMEMBER . . .

■ A canvas board is a good support for beginners because it is rigid and has a suitable texture. You can also use special paper that comes in a pad and feels like canvas. The most appropriate size for painting should not exceed 50 cm in length.

Brushes

The brush is the main implement for oil painting. This tool is made up of the handle, the ferrule, and the hair or bristle. Although all brushes have these three components, there is a wide variety to choose from. Brushes are classified by the hardness and shape of their hair. Each brush has its own particular function; therefore, it is essential to become familiar with the most important characteristics.

The hairs or bristles.

The ferrule.

The handle.

Anatomy of the Brush

All brushes are made up of a handle, which artists use to hold them; a ferrule, a metal band that keeps the hairs together; and hairs or bristles, with which the paint is applied to the canvas. Nonetheless, the shape and arrangement of these parts vary.

Types of Hair: Hog Hair and Synthetic

The hair of paintbrushes is made of different materials, ranging from natural—animal hair—to synthetic. The most common type of natural hair used is hog's hair. Each bristle has a natural split, or "flag" at the tip, which allows thick or heavy paint to be spread evenly and smoothly.

Synthetic hair is the other commonly used hair in paintbrushes. This is made of bristles that imitate high-quality soft hairs, such as sable hair or mongoose hair. Synthetic hair brushes have been perfected over the years. High-quality synthetic hair brushes that hold large quantities of paint and produce soft and prolonged strokes are now available.

Types of Brushes

The diameter and width of the ferrule set the shape for the collection of hairs.

Oil brushes can be round or flat. The round brushes have a rounded or pointed tip. Flat brushes are either filbert type or flat-tipped. The hairs of flat brushes are all the same length. These brushes are highly versatile because they

A. A hog-bristle brush.
B. A synthetic brush.

A B

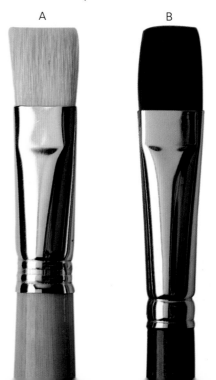

Quality and Recommendations

While there are many high-quality hog-bristle brushes available on the market, you should choose only those that are guaranteed to retain their hair. Don't be fooled into buying cheaper ones because they will inevitably give bad results; however, the only way of knowing if a brush is good is by testing it out. If you happen to buy a cheaper brush, let it soak overnight in turpentine so that the handle will expand and tighten its grip on the hairs.

render hard edges and like the wide flat paintbrushes are ideal for filling in large areas. The filbert brush is shaped like an almond and is highly effective for outlining and modeling shapes.

A. Round brush.
B. Flat brush.
C. Flat filbert brush.

Wide synthetic paintbrush.

Fan Brushes

As its name indicates, the fan brush opens out in the form of a fan. It is used to paint blends and glazes and is normally made of high-quality synthetic hair.

Fan paintbrush.

A suitable set of brushes for beginners would include a medium synthetic wide paintbrush (6), a No. 6 round synthetic brush (5), a No. 6 hog-bristle filbert brush (4), a No. 6 and a No. 14 flat brush (3), a No. 12 and a No. 18 filbert brush (2), and a No. 20 flat brush (1). On page 20, another range of brushes for beginners similar to this range is shown. Either set will work well.

Wide Brushes

Wide brushes (utility brushes like those used for house painting) are flat paintbrushes that come in a variety of sizes. The handle is flat and they are excellent for painting with large amounts of paint. The wide brush is extremely useful in oil painting because it can be used to cover broad areas, thus quickly resolving the first applications on the canvas.

There are many types of wide brushes available. The cheapest ones can be purchased in hardware stores, but they will probably lose their hair. Synthetic wide brushes give excellent results because they are soft and elastic and absorb plenty of paint.

REMEMBER . . .

■ Brushes should be cleaned after use with turpentine and then soap.

■ High-quality brushes are expensive; therefore, it is advisable to begin working with medium-quality brushes.

■ When you are going to spend some time without painting, keep some mothballs with your brushes to protect them.

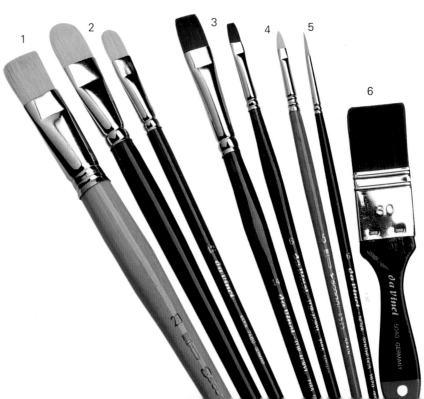

Palettes, Palette Knives, and Palette Cups

Palettes are used to mix paint colors. These handy flat surfaces are made from various nonporous materials. Other tools used in oil painting include palette knives, which are used both for painting and cleaning, as well as palette cups, which hold the solvent and the turpentine.

Rectangular palettes.

Oval palettes.

Palettes

The artist uses the palette to mix paints before applying them to the canvas. The palette normally has a hole so that the artist can hold it easily with one hand while painting with the other. Palettes are made of plastic, wood, or paper.

RECTANGULAR PALETTES

The rectangular palette is manufactured to fit inside a paint box. These palettes come in as many types and sizes as there are paint boxes and cases on the market.

The palette should be varnished before use to prevent its surface from absorbing paint. Most medium-quality palettes are sold varnished, so they're ready for mixing colors when you buy them.

Qualities

The anatomy of a palette knife.

Good quality palettes are made of wood and are stained and varnished. Their edges are sanded down, and the hole through which the thumb is inserted has an anatomical slant on the edge.

There are also disposable paper palettes. When you finish using one sheet, you tear it off and go to the next. They come in a pad and are ideal for outdoor use.

OVAL PALETTES

The oval palette comes in all sizes and is normally used in the studio. It is the most comfortable because it doesn't have corners. The largest of these palettes are counterbalanced and reinforced by strips of wood on the lower side.

Plastic palettes, suitable for school use or small works, are not recommended for beginners.

Some palette knives are shaped like a trowel (1), some have a rounded tip (2), and others are shaped like a knife (3). The angle of the blade can be more or less pronounced, with a flat or triangular tip.

Palette Cups

Palette cups are small containers that clip onto the edge of the palette so that a supply of oil and turpentine is always on hand.

Palette cups can be made of metal or plastic, the latter being the simplest and most economical. They are conical and round and can be purchased separately or in pairs.

Two types of palette cups: one made of plastic (1) and one made of metal (2).

IMPROVISED PALETTES

You can use any smooth surface as a palette: an old plate or even a piece of cardboard or wood.

Different types of palette knives.

Palette Knives

The palette knife is a painting tool in the form of a knife or a trowel. It is used to spread and shape paint.

The palette knife is made of a flat strip of steel connected to the handle by a metal ferrule.

The palette knife can be used to flatten paint, or create a heavy buildup of paint.

In addition, it can also be used to mix paint and clean the palette after the picture has been finished.

Easels and Paint Boxes

To paint in oil you only need a canvas, brushes, and paint, but there are several items that make the task more comfortable, such as an easel for supporting the painting and a box for transporting your painting equipment.

Easels

The artist uses the easel to keep the canvas firmly secured while painting. The easel is made of wood or metal. It can be adjusted for height and has a series of clips that allow the painting to be fastened to it.

There are two main types of easels: the folding type and the workshop easel. Folding easels have extendible parts with metal wing nuts that allow the legs to be lengthened; they are light structures but are not as sturdy as workshop easels.

Workshop easels cannot be folded up; they take up a lot of room in the studio, but they're highly stable. One type of workshop easel is the studio easel, which is made of thick wood. Certain kinds even allow the artist to control the angle of the painting.

Artists who mainly paint small works can opt for a tabletop easel; they are small, but they save a lot of space and permit the painter to work at a table or desk.

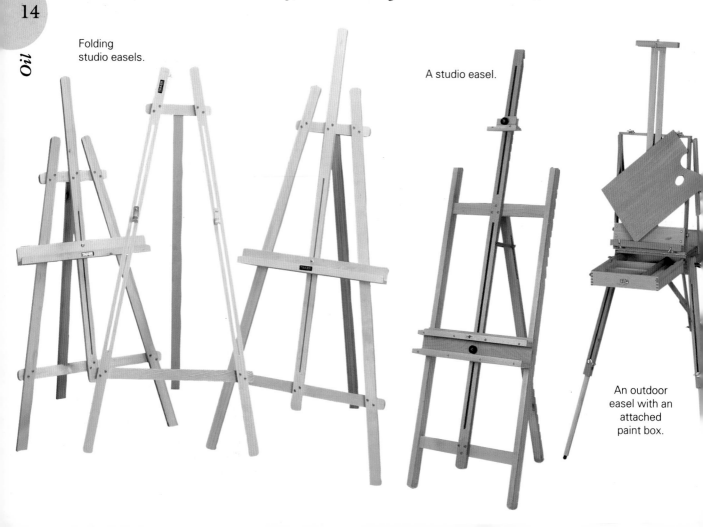

Folding studio easels.

A studio easel.

An outdoor easel with an attached paint box.

Paint Boxes

Paint boxes are used to hold, transport, and arrange your painting equipment. There are several types on the market from which to choose. In addition to different qualities, they can be bought full or empty. It is not essential to purchase the most expensive one, a medium-quality paint box is enough to get started in painting.

EMPTY BOXES AND FULL BOXES

An empty paint box is ideal if you already have your own painting materials, if you merely want to exchange your old box for something newer and better, or if you want to fill your paint box with a combination of different brands and qualities of oil paints.

Empty boxes allow the user to fill them according to their own preferences. Full paint boxes, on the other hand, are sold with a complete range of colors of a determined brand as well as one bottle of oil and one bottle of turpentine.

Also included are various compartments made of plastic or metal.

Most paint boxes provide a palette that is designed to fit perfectly inside; in double paint boxes (the most complete type), the palette also doubles as a separation panel. In simpler paint boxes the palette fits into guide strips inserted in the lid. Furthermore, these guide strips also allow the painter to carry canvas board while it is still wet, because they are separated from the palette and the lid.

Empty paint boxes allow painters to fill them according to their own preferences.

The classic paint box comes filled with a complete range of colors of a specific brand as well as palette cups for oil and turpentine.

FRENCH EASELS

The French easel is a case that includes everything you might possibly need to paint, in a small space. This type of easel is practical for working outside the studio. Once open, the artist can paint comfortably.

A simple but practical outdoor easel. Lacking a cover, it closes up with a palette inside.

REMEMBER . . .

■ If you are going to buy a sturdy workshop easel, choose one that has wheels because it will prove more practical.

■ When you buy a folding easel, ensure that it is sturdy when it is set up and that the canvas can be securely fastened to it both from above and below.

A tabletop easel opened up.

Solvents and Mediums for Oil Painting

Oil paints are made up of oil and pigment. In addition, there are many products that lend oil colors special characteristics, such as adding gloss, thickening, creating transparencies and accelerating drying time. Apart from the substances that can be added to the oil paint, there are complementary materials that aren't essential for oil painting but that can make clean up, organization, and preparation of the supports much easier.

Linseed oil.

Linseed Oil

Linseed oil is the most commonly used oil medium. When it dries, it forms a tough adhesive film either by itself or mixed with paint, which makes it resistant to aging. Nonetheless, after drying it tends to make the colors yellow slightly. When it is added to thin paint it must be mixed with a tiny amount of turpentine to prevent the canvas from warping after it has dried.

Poppyseed Oil

Poppyseed oil is extracted from the seeds of various poppy plants. It dries slowly and slightly yellows the lighter colors. This oil is ideal for reducing the density of whites and blues.

Turpentine

Turpentine is obtained from distilling resinous sap from a certain variety of pine trees. Used with thick oil, turpentine lends the paint a softer and more fluid consistency. The use of turpentine to thin paint is ideal for sketching and applying the first layers of paint in a painting. It is also used for cleaning painting implements like brushes and palettes.

Turpentine.

Mineral spirits.

■ Turpentine is used both for diluting oil paint and for cleaning brushes and the palette.

■ Mineral spirits used excessively reduce the shine from the paint and make the picture's surface fragile.

■ Too much cobalt drier damages the paint, producing cuts, warping, and color loss.

Primers

Supports used for painting must be primed to prevent the oil from coming into contact with the surface. You may also alter the surface of the canvas by applying the gesso or acrylic primer in varying thickness or by using modeling paste.

Cobalt drier.

Mineral Spirits

Mineral spirits is refined and purified mineral oil. It is completely transparent and odorless and evaporates without leaving any trace. It penetrates the paint easily and is manufactured especially for oil painters who are allergic to turpentine.

1. Acrylic primer.
2. Priming medium.

Cobalt Drier

Cobalt drier accelerates the drying time of oil paint, but it cannot be more than 5 percent of the total mixture. In other words, 2 to 3 drops for a walnut-sized squirt of color, and only in the slowest drying colors. It must be thoroughly mixed with the paint before use.

Recommendations

Among the equipment used in oil painting, there are containers for storing the brushes and turpentine; charcoal for sketching on the canvas, soft erasers for erasing charcoal, and a rag.

Materials

17

Oil

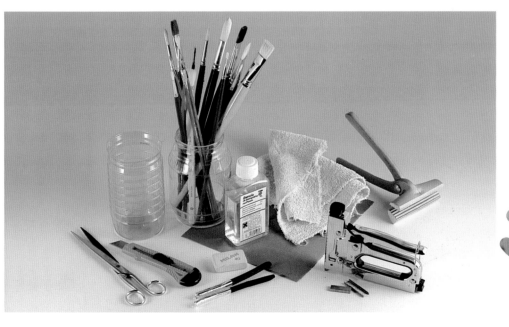

Different painting equipment.

Hand cream is ideal for removing paint residue from your hands without damaging the skin.

How to Use the Paint

Although it is relatively easy to work with oil paints, for those who are not familiar with the techniques, certain details may seem somewhat of a mystery. This chapter shows you what you can do with the paint.

Placing the Paint on the Palette

To begin, squirt some paint out of the tube. This should be done carefully if you only require a small amount. Bear in mind that the colors must be arranged on the palette in a way that you can see at a glance which one you need. (See "Using the Palette," pages 20–29.)

Mixing the Paint

When mixing colors on the palette, you can use a brush or a palette knife. The best way is to use a palette knife and wipe it clean after each color, so as not to contaminate your original colors. Because this takes more time, painters choose to dirty their colors slightly and mix their colors with the brush.

Painting in oil entails mixing paints with the brush because it is faster and easier than using a palette knife.

Mixing Colors with the Brush

1. Load a little color from the palette and apply it to the canvas.

2. If you don't want to use the palette knife, you'll have to use the brush, which means you may dirty the colors slightly when you load them onto the brush.

3. Mix the two colors in the a[rea of] your palette reserved for mixi[ng]

Mixing Colors with the Palette Knife

1. Take some color and put it in the center of the palette.

2. Clean the palette knife with a piece of newspaper.

3. Take a little of the other color that you want to use in the mix.

4. Place it with the first colo[r and] mix them thoroughly.

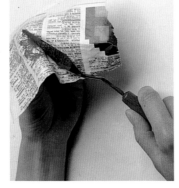

Turpentine and Oil Paint

Turpentine is an indispensable complement for oil painting because it is used to dilute the paint, to reduce its intensity, or to make it more transparent. It is also used as a solvent for washing brushes and the palette. So, in order to preserve the purity of the color, we recommend you use a jar of turpentine to clean the brushes and a different one for diluting the paint.

It is advisable to use one jar of turpentine for cleaning the brushes and a separate one for diluting the paint.

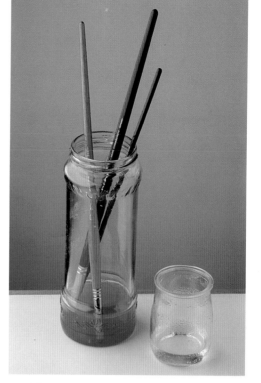

Applying the Paint

Oil paint is versatile, which means it can be applied to the canvas in varying densities to achieve different results.

Another way of applying paint is the impasto method—loading the brush with plenty of paint and "placing" it on the canvas without spreading it out. This procedure creates a relief surface but takes a long time to dry.

Oil paint can be applied just as it comes from the tube. When it is done this way the color is opaque and has an excellent covering capacity.

When diluted with turpentine, the paint becomes transparent and loses its shine. Used in this way, oil paint is ideal for creating backgrounds, painting sketches, or applying the first washes of color because it dries quicker and does not muddy the colors applied on top of it. Furthermore, the gesture of the brushstroke is maintained.

By diluting oil paint with linseed oil it is possible to obtain a certain degree of transparency and shine.

Another way of applying oil paint is with the scrubbing technique. This entails loading the brush with a little paint and scrubbing the surface of the canvas with the bristles of the brush until you achieve a result like the one shown.

How to Use the Brush

The brush is the implement we use to apply the paint to the support and the thickness and quality of the strokes depend on it. A good brush makes the task much simpler; a bad brush may compel the artist to abandon the work.

The brush should be held lightly between the fingers in order to paint light and fresh brushstrokes.

By holding the brush like a stick, you can apply as much pressure as you want. This method is more apt for use with wide and large brushes than for painting details.

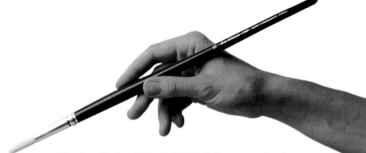

How the Brush Is Held

Generally, the brush is held between the fingers like a pencil, or within the entire hand like a stick. In addition, there are countless other ways of holding it, depending on what you want to achieve and how comfortable you feel with it. Despite this, if you hold the brush by the ferrule you lose agility, the brush becomes less versatile, and your stroke becomes more awkward.

How Many Brushes Do We Need?

Given that oil paint stains and brushes are not easy to clean, the more brushes you have at your disposal, the better because this will save you the time of having to stop and clean your brushes while you work. But, for beginners, the following brushes will suffice: a wide hog-bristle paintbrush for painting the background (1), a hog-bristle filbert No. 18 (2) and a No. 14 synthetic flat brush (3) for painting broad areas with thick brushstrokes, a No. 14 round brush (4), a No. 12 filbert brush (5) and another No. 12 long-haired filbert brush (6) for defining colors and achieving volume, and a No. 6 synthetic flat brush (7) and No. 4 round brush for small areas and details. See page 11 for an alternative range of brushes for getting started in oil painting, which is similar and equally valid to the range provided here.

How to Care for Brushes

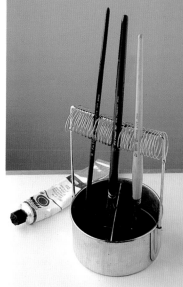

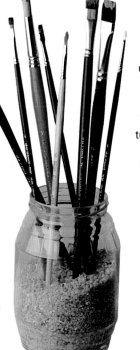

Once the brushes are clean, they should be left with the hair pointing upward until the next painting session. If you don't plan on using them for some time, it is advisable to keep them in an air-tight container to protect them from dust.

While you are painting, you can keep your brushes in a jar filled with sand, so that several of them can be stored together without their touching one another. If you are not going to use a brush again, you can leave it to soak in a brush holder filled with turpentine.

When you no longer need to use a particular brush, leave it to soak in a brush holder filled with turpentine. This will make it easier to clean later on.

While you are painting it's easy to keep your paint-filled brushes ready to use by placing them in a jar filled with sand so that several can be stored together without coming into contact with one another. This is especially useful when you are painting with many colors.

The rag is an invaluable aid for absorbing excess paint from the brush or for cleaning it while you are painting.

How to Clean Brushes

The brushes are cleaned by soaking the hair in turpentine, but if you are not going to use them until the next session, it is important to clean them with soap afterward to keep the hair in good condition.

1. Remove any excess paint with newspaper.

2. Dilute any paint left on the brush in turpentine. Then dry it before you continue painting.

3. If you have no further use for a certain brush during a painting session, wash it with soap and water (dishwashing liquid is fine), rubbing it softly against the palm of your hand in circular movements.

4. Then rinse it out well under the faucet.

5. Once you have dried the brush with a rag, restore the hairs to their original shape with your fingers.

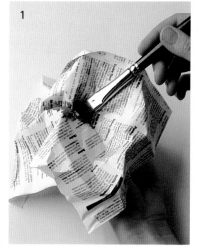

REMEMBER . . .

■ To avoid damaging your brushes, make sure the ferrule and handle are not submerged in the turpentine when the brushes are left to soak.

■ You will know your brush is completely clean when, on washing it, the soap suds turn white. If this does not happen, wash them again until all the paint has been removed.

Brushwork in Oil

The versatility of the brush together with oil paint allows the artist to obtain fine or thick strokes, using a little or a lot of paint, and thus creating textures, dramatic effects, and movement.

Using the Brush

The brush can be used to create thick brush-strokes or fine lines, depending on how it is used and the amount of pressure that is exerted on the support.

Thick strokes are obtained by using the brush flat with the ferrule parallel with the surface.

Fine lines are obtained by twisting the brush.

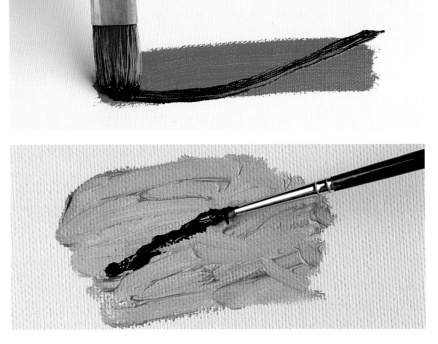

When painting on a wet layer, the paint has to be "placed" softly on top without spreading the color over the surface with pressure.

These effects, which could be used to suggest the turbulence of a river or curly hair, are obtained by twisting the brush on its tip.

This effect is caused by the loss of consistency in the paint and is obtained by scraping the paint across the surface until the stroke fragments. It can be used to suggest movement or speed.

These tiny strokes of color create a vibrant and dynamic optical effect.

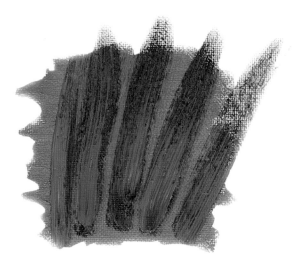

This type of stroke can be used to indicate the direction or strength of a line.

By lightly scrubbing, using barely any paint, this somewhat diffused and blurred mark can be used to suggest, for instance, vegetation in the background.

The brushstroke is fundamental for suggesting forms and the nature and direction of bodies. In this case, these brushstrokes could be used to suggest the current of a stream, curly hair, or even a shooting star in the sky.

Mounting the Canvas

Oil paint must be painted on a stable support, a tensed and smooth surface that will not hinder you while you paint. You cannot paint on loose fabric or creased paper; these must be mounted and tightly stretched on a stretcher. While it is not difficult to mount a stretcher, it requires some practice.

Mounting the Canvas on the Stretcher

The following instructions explain how to go about mounting canvas on a stretcher.

1. To mount a canvas on a stretcher, you will need a staple gun, canvas pliers, a canvas, and a stretcher. Cut the canvas so that it can be folded over the corners of the stretcher. Place the canvas, the primed surface facing downward, on the floor and position the stretcher on top. The two sides of a stretcher are not exactly equal: The outer edges are thicker than the inner edges so that the stretcher is not visible when the canvas is stretched. Make sure that this is the face against which the canvas will be placed.

2. Stretch and staple in the form of a cross—that is, first fold one side and staple it to the wood in the center. Then take the canvas from the opposite side, stretching it with the help of the pliers. Hold the canvas firmly with your hand and staple it down in the center. Once you have finished the two sides, repeat the operation on the two remaining sides. The stretching of the canvas must be performed with great care so as to not rip it.

3. Now that each one of the four sides has been stapled, begin stretching it—search for the point of maximum tension closest to the central staple, with the minimum distance necessary so that the pliers do not pull out the staples already fastened.

4. Leave the corners until last. Fold the canvas over the stretcher at one corner. Note how there will be a slight excess of canvas; tuck it under the two corners as shown in the photograph. First, stretch and staple along one side, ensuring that you remove the slack. Last, stretch the other side to obtain a completely tensed canvas.

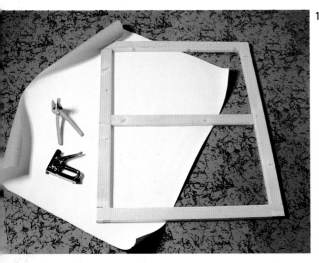

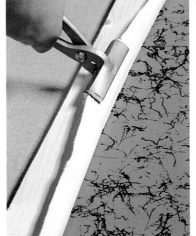

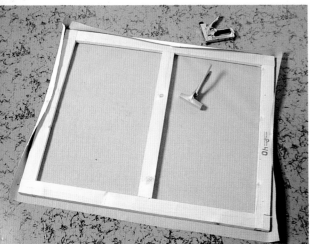

1. Wet the entire surface of the paper first.

2. The dampened paper should be attached to the stretcher with drawing pins or it can be glued.

Mounting Paper

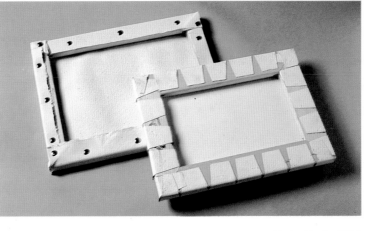

To mount a sheet of paper on a stretcher, 1 first wet it and lay it on a flat surface. The paper should always be larger than the stretcher so that it can be folded over the edges and corners.

Fold the paper over the stretcher, attach it with drawing pins around the perimeter beginning with the central parts, and finish off at the corners. Once the paper has dried, it will contract, producing a firm and tensed surface, ready for priming.

Plywood and Cardboard

2

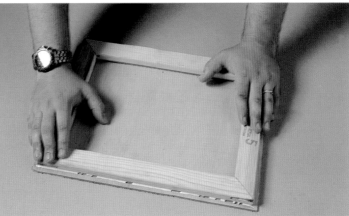

Plywood or masonite is easy to mount on a stretcher. All that is required to do this is some glue, sandpaper, and tacks. A staple gun can also be used, but tacks will secure it more firmly.

1. The piece of plywood or masonite you are going to use should be slightly larger than the stretcher. Add plenty of glue to the stretcher and place it over the panel, lightly pressing down to make the two stick together. Then drive several nails through the two pieces of wood. Leave them to dry for a few hours and then remove the overlapping board by running the knife around the edges of the stretcher.

2. Sand down the corners with a piece of 3 sandpaper.

3. Cardboard is mounted in the same way as plywood only the overlapping parts can be folded back.

REMEMBER . . .

■ It is essential that soft supports be tightly stretched, so they are easy to paint on and do not crack once they have dried.

■ To achieve a greater tension when stretching your canvas, dampen the reverse side with water so that it shrinks when it dries.

Priming the Support

Oil paint should never come into direct contact with the support, otherwise it would ruin it. Whatever surface you choose to paint on, it must always be protected by some sort of primer, the type of which depends on whether the support is made of canvas, wood, or cardboard.

What Is a Primer?

A primer is a layer that reduces the absorbing capacity of the support, preventing the paint from losing its consistency.

There is a relatively simple and effective priming method usually used for oil sketches and fast paintings on cardboard, wood, or paper. This consists of rubbing a clove of garlic over the surface to seal the pores from the liquid.

You can prime a canvas with an acrylic or latex primer. First dilute the primer until you obtain a milky substance to fill in the pores. Then using an ordinary decorator's paintbrush or a roller, apply the primer in one specific direction until the entire surface is covered and completely soaked. Apply the second layer transversely; the third layer, denser and with zinc white pigment or another color lengthwise. Remember not to let the paintbrush dry; wash it with water and dry it thoroughly.

Latex.

Modeling paste.

Priming Canvas

Priming must preserve the elasticity of the support and provide a sealing capacity. The most commonly used substances to prime canvas are latex primer, gesso (also known as Spanish white), and acrylic primer. All these can be bought in any art supply store.

Latex and acrylic primers are resinous varnishes that have a shiny appearance and are elastic when dry. These substances should only be applied to a canvas once it has been mounted on a stretcher to guarantee a tight stretch.

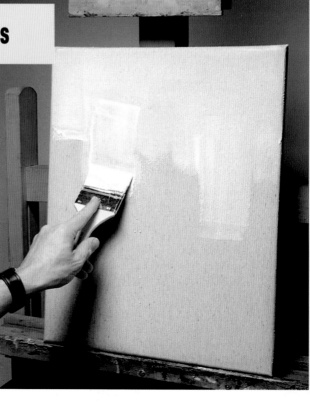

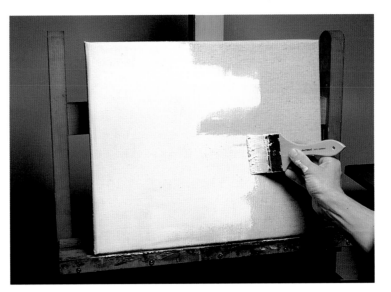

Application of gesso, also known as Spanish white, with a wide paintbrush.

Jars of gesso.

Priming with Gesso

Gesso has an enormous covering capacity because it is very dense. It is applied with a wide decorator's paintbrush over the raw surface of the canvas. Similar to acrylic and latex, the priming operation must be performed in several transversal layers, finishing with smooth and straight strokes, across the grain of the canvas.

Gesso must be applied in various layers, crisscrossing the direction of the brush. Three layers are enough to obtain a good priming.

Priming Rigid Supports

Rigid supports must be primed as carefully as canvases. The handiest rigid support is plywood because it is manufactured from several layers of wood and is particularly resistant to warping produced by dampness and other climatic changes. The priming procedure for masonite and cardboard is the same as for wood—apply several cross-layers of gesso, latex, or acrylic.

1. White base. It provides a suitable texture on a rigid support.
2. Acrylic primer.

Priming with a white base allows the texture of the support to be completely covered.

Once the gesso has completely dried, rub a piece of sandpaper over the surface to sand it down.

How to Use the Palette

The palette is essential for oil painting because it is used to hold and mix the paint.

Size and Shape of the Palette

The oil palette can be made of plastic or wood. Professional artists tend to prefer wood, although a plastic palette is easy to clean.

The size of the palette you choose will depend on the number of mixes you want to do. A small palette may be too small of a mixing ground, so the best advice is to begin with a medium-sized one.

The shape of your palette is an entirely personal matter because one shape is no better than another. However, rectangular palettes fit more easily into a paint box, making them easier to transport.

REMEMBER . . .

■ The palette should be big enough so you can mix colors in the center.

■ It is important to clean the palette after each session, to prevent the mixes from contaminating your new mixes on the next day and also to prevent the oil from drying on the surface.

■ You can improvise and make a palette with a piece of wood or any other flat surface.

Arranging Colors on the Palette

You can arrange the colors on the palette according to your preferences. We suggest you try the following two arrangements to see which one best suits your needs.

Organize the colors into ranges: cool colors (blues and greens), warm colors (yellows, reds, and earth tones), using white as a separator.

Another way is to arrange them by intensity, starting with white and ending with black.

In order to start painting with oils, you can separate the colors into cool and warm ranges with white in between. Note how the black is slightly farther away from the rest of the colors because it is rarely used and can dirty the other colors.

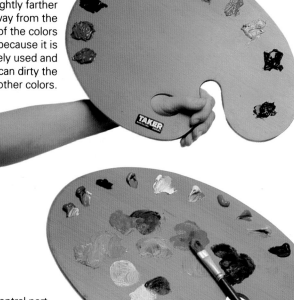

The central part of the palette is reserved for mixing colors.

Cleaning the Palette

Once you have finished painting, it is advisable to clean the palette, to prepare it for the next painting session and to prevent the oil from drying on it and producing an irregular surface.

If you plan to continue painting the following day, clean only the center of the palette, the mixing area, leaving the portions of paint intact so that you can use them in the next session. If you are not going to paint for several days, clean the entire surface.

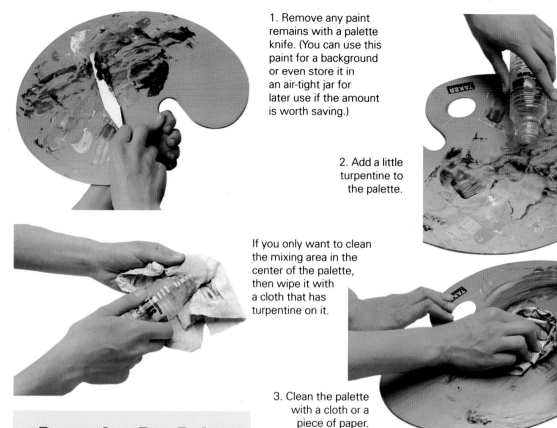

1. Remove any paint remains with a palette knife. (You can use this paint for a background or even store it in an air-tight jar for later use if the amount is worth saving.)

2. Add a little turpentine to the palette.

If you only want to clean the mixing area in the center of the palette, then wipe it with a cloth that has turpentine on it.

3. Clean the palette with a cloth or a piece of paper.

Removing Dry Paint

If you forgot to clean your palette after your painting session and did not continue painting the next day, the best way to remove any paint that has dried on the surface of the palette is to cut away the lumps with a knife and then sand down the surface with a piece of sandpaper.

If you have let the paint dry on the palette and the roughness disturbs your work, sand it down with some sandpaper until it is smooth.

Improvising a Palette

If you feel like painting and don't have a palette at hand, you can use an old plate or almost any flat surface. Here we have used an old paper tray.

Any piece of wood can serve as a palette, although it is advisable to apply a layer of olive oil beforehand so that the surface is smooth and does not absorb too much oil paint.

The Drawing

It is essential to make a preliminary drawing for a precise oil painting, especially if you are just starting out in the medium. The drawing of the subject on the canvas becomes the guidelines for the artist to follow while painting.

The Importance of the Drawing

Apart from the inherent value of the drawing, for the oil painter drawing is another tool. Through sketches, the artist can study the different aspects of the subject: its shape, the incidence of light over it as well as the parts in shade and those in light. In this way, when you come to paint your subject, you will have a clear idea of how you are going to resolve your work.

Drawing Techniques

Without doubt, if you want to practice drawing, it is always best to draw free-hand while studying the subject. The drawing

techniques demonstrated here should only be used as a last resort. Nonetheless, you may feel that you do not have much time to spend on the drawing or that the theme is too complicated; however, we must emphasize that drawing is a captivating and essential artistic pastime and therefore must be pursued.

There are a couple of tricks for drawing the motif onto the canvas.

MAKING A GRID

If you are going to paint a motif from a photograph, you can draw a grid over it and another proportionally equal to it on the canvas. In this way the lines and the spaces among them will guide you in situating the photographic elements onto the surface of the canvas.

Basic Techniques

Oil

30

It is essential to draw sketches of the subject in order to study it in depth.

1. We have chosen this artichoke photograph as our theme. We first draw a grid on top.

2. With a stick of charcoal, we draw a grid that is proportionally equal to the one we have drawn over the photograph. Then we draw the subject using the lines to guide us.

3. Once the drawing is complete, the lines of the grid will remain evident, but this should not pose a problem because they can be easily erased.

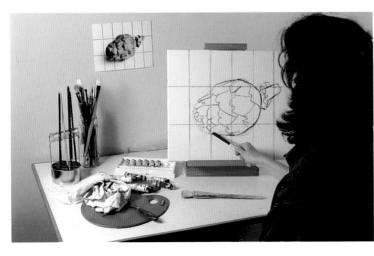

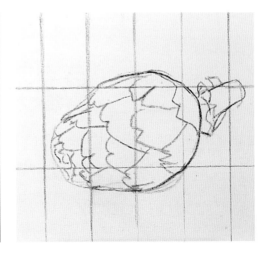

PROJECTING A SLIDE

Projecting a slide is a simple method for drawing a theme in charcoal, but you must have a slide of the subject you wish to paint in order to go about it.

1. Choose the subject in a slide.

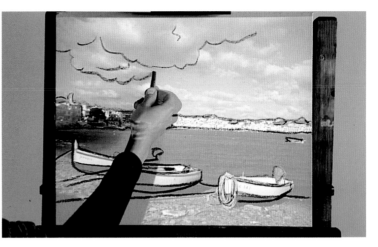

2. Project it onto the canvas and then trace over the most important lines with a stick of charcoal.

Erasing a Charcoal Drawing

Once the subject has been drawn on the canvas, many artists erase the drawing because charcoal tends to dirty the lighter colors. Charcoal does not have good adhering capacity, so it is relatively easy to remove lightly drawn marks simply by blowing over the surface of the canvas. However, if you want a dust-free canvas without removing the lines of the drawing, you can achieve this by wiping the surface with a rag or by brushing it with a soft brush.

To remove excess charcoal from the canvas, clean the surface with a soft paintbrush. This will easily remove the charcoal dust.

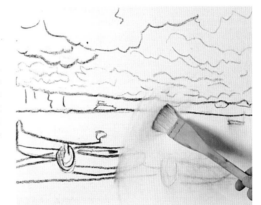

If you are in a hurry, use a rag to erase the charcoal.

If you want, erase the charcoal softly so the lines of the drawing will remain visible, but allow you to paint over them.

Fixing a Drawing

REMEMBER . . .

■ If you fix the drawing it will be difficult to erase it later on.
■ If you don't want to dirty the lighter colors, remove the excess charcoal before you begin to paint.
■ In addition to using drawing techniques, it is important to draw sketches and keep notes.

If you are worried that the charcoal drawing will deteriorate while you are painting, you can apply a fixative to the lines. Remember that once the drawing is fixed, it will be extremely difficult to erase it later on.

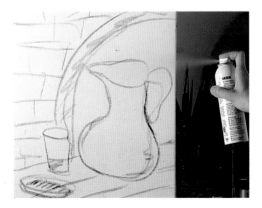

One Color

Before you immerse yourself in the world of color it is advisable to understand the effects of oil paint by working with a single color and seeing the tonal range it can produce.

One way of increasing the transparency of a color is by diluting it with increasingly greater amounts of turpentine.

The more turpentine that is added, the more transparent the paint becomes.

The Tones

Any color can be used to produce an entire series of tones ranging from light to dark. Tones are really different degrees of the intensity of light of a color.

Obtaining Tones

The two ways of obtaining a tonal range of a color: by diluting the paint in turpentine or toning down the color with white.

CREATING TONES BY DILUTING THE PAINT

By diluting oil paint in turpentine, the pigment becomes less concentrated and the tone of the color lightens. So, the more the paint is toned down, the more transparent it becomes.

This treatment of the paint through transparency is similar to that obtained in watercolor.

CREATING TONES BY ADDING WHITE

Lightening a color with white is the most appropriate method in oil painting for obtaining a range of tones. In this way, oil's characteristic opacity and covering capacity is maintained, which allows the artist to paint with either thin or heavy layers.

Colors that Change

Mixing a color with white or black in order to reduce or increase the color's natural tone allows the artist to work with oil paint in its original consistency. Nonetheless, this method has its drawbacks because certain colors change when they're mixed. Red mixed with white becomes pink; with black, brown. Yellow mixed with black becomes green. The way to avoid these changes is to create tonal ranges using related colors. For instance, yellow can be darkened by adding ocher; red can be darkened by adding carmine.

By lightening a color with white, you maintain the opacity of the paint and can thus work with impastos.

The tone of a color can be modified by adding white; the greater the amount of white, the lighter the tone.

This small range of tones of turquoise blue was obtained by lightening it with white and darkening it with black. The original color can be seen in the center.

In many cases, the tone of a color can be darkened by adding small amounts of black.

By lightening yellow with white we obtain a pale yellow; if we attempt to darken the same color with black we get a green tone.

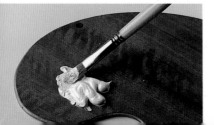

Gradating a Color

There are two primary methods for gradating an oil paint color. One involves gradually reducing the tone by adding white to the chosen color; the other, by diluting the color in turpentine. The main difference between these two methods is that one produces an opaque result; the other, a transparent one.

GRADATING A COLOR WITH WHITE

Although it might seem somewhat complicated to gradate a color with white, it is important to master this procedure because if you have decided to try your hand at oil painting, sooner or later you will have to carry out an opaque gradation in some part of your painting.

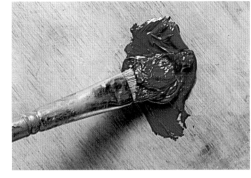

1. Place the color you want to gradate on the palette. Here we are going to use rose madder and also a touch of white. Then load some of the rose madder paint on the brush.

2. Paint about one-quarter of the paper with the color.

3. Now mix the white with the remaining rose madder paint on the brush. Note that the resulting color is lighter than the original. In this case we have chosen a color that varies on adding white. (Rose madder gradually becomes pink as increasingly greater amounts of white are added.)

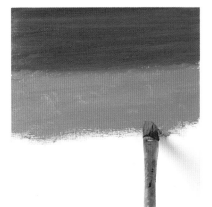

4. Repeat the operation until the entire surface of the canvas is covered with four strips of color, each of which is lighter than the previous one.

5. Note how the bottom layer is almost pure white. This is how a complete gradation should be obtained.

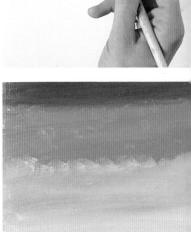

6. Now dip a soft-hair synthetic brush in turpentine.

7. Blend the strips together by barely grazing the surface to prevent it from carrying the color with it.

8. The result is an opaque gradation that begins from a pure color and finishes in its lightest intensity.

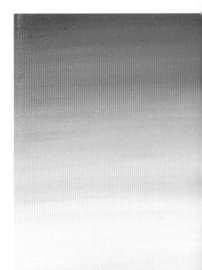

Vermilion mixed with white produces pink, by adding black it turns brown.

A complete range of vermilion using carmine to darken it produces more suitable tones than if we had used black.

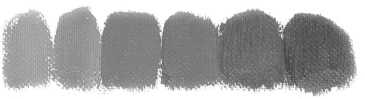

GRADATING A COLOR WITH TURPENTINE

It is quite easy to gradate a color with turpentine. The secret of a successful gradation lies in its application in a single direction without going back over something you have already done.

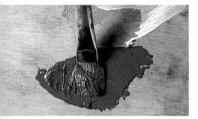

1. Load some color from the palette.

2. Paint a strip of the upper part of the paper.

3. Squeeze out the excess paint with a rag.

4. Load some turpentine onto the brush.

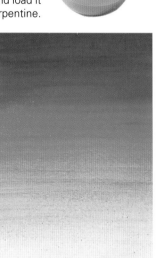

5. Apply the half-diluted color downward. If you see that the hair is drying, don't load any more paint on the brush; on the contrary, load more turpentine and paint to the end.

6. The result of these first steps is irregular; to make it softer take up a soft paintbrush (synthetic, for instance) and load it with turpentine.

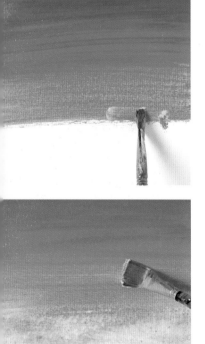

7. Pass lightly over the entire surface of the gradation from the darkest area to the lightest.

8. The result is a quick-drying subtle gradation that is ideal for painting a background.

Painting with One Color

A monochromatic painting consists of a series of tones of a single color to build forms and suggest volumes through contrasts.

When painting in oil with one color it is essential to use another color to create the various tones of the host color. The most commonly used color to do this is white.

If you are a beginning oil painter, it is best to begin with one color plus white because this allows you to learn the tricks of the technique while leaving the problems of color to one side for the moment. Furthermore, the monochromatic painting is an important lesson in understanding light and shadow and tones and their importance in successfully resolving the tonal values of a painting.

REMEMBER . . .

■ Colors diluted in turpentine become more transparent.

■ We can darken or lighten a color by adding black or white to it.

■ White takes longer to dry than other colors; therefore, we don't recommend you gradate with white because the colors you apply on top of the white will dry slower and cracking will occur over the years.

■ Tonal errors can be rectified by darkening or brightening the tone.

■ Never hurry to finish a painting. The artist loses perspective and objectivity about his work when he spends too many consecutive hours in front of the canvas.

■ If you think you have made a mistake, don't try to rectify it immediately. Rest, forget about the painting for a while and do something else. When you later reexamine the error you will see it in a more objective light.

An Artichoke in Black and White

We are going to paint this artichoke using black as our main color because it is the darkest color and it can be used to create a wide range of tones when mixed with white.

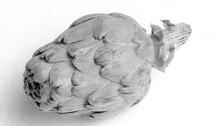

This humble artichoke may at first glance appear easy, but it will pose more problems than we anticipated.

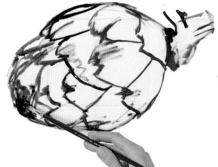

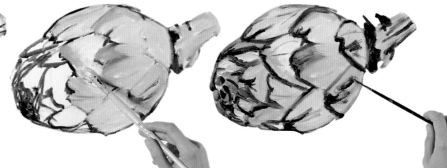

1. To draw the artichoke in charcoal on a canvas we have used the grid procedure. (See "The Drawing," page 30.) Then we paint over the lines with a diluted black so that it dries fast and does not significantly dirty the tones we will eventually paint on top.

2. With the tone we have obtained from mixing black and white on the palette, we paint the entire artichoke. Note the way brushstrokes are applied to indicate the direction of the leaves. We also take advantage of the background color to slightly darken certain parts of the vegetable.

3. With a fine brush loaded with black, we outline the leaves by applying light strokes, to prevent the leaves from mixing too much with the background. The darkest parts are suggested by softly scrubbing those areas with the brush.

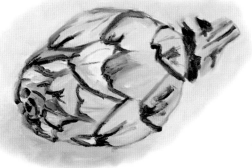

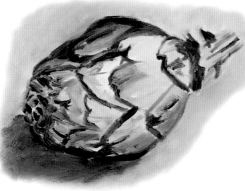

4. The background has been painted with a light gray and the shadow has been suggested. The work is not finished and does not yet reveal any interesting contrasts.

5. Having painted the artichoke's shadow and examined our contrast, we have darkened the background. Using a fine brush we retouch the details and complex layers of leaves.

6. Now there is a considerable layer of paint on the canvas, so when the details are painted using a fine brush, it gets ever more muddy, producing tones that are lighter and darker than those desired. To prevent this, we clean the brush with a rag after every application.

7. The artichoke and the background blend together because they possess a similar tonal intensity. Looking at the subject we can see that the artichoke is indistinguishable from the background. This is something that will have to be rectified.

8. The picture was left to dry for a few days. Then we applied white over the background. This helps to separate it from the artichoke, thus giving it a more three-dimensional, realistic look.

Various Colors

The world of color is as fascinating as it is complex, so when you begin to paint in oil, it is recommended that you select fewer colors to paint with and obtain the others with mixes.

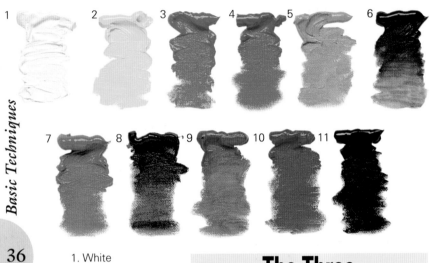

1. White
2. Cadmium yellow (primary color)
3. Vermilion
4. Carmine (primary color)
5. Yellow ocher
6. Burnt umber
7. Cadmium green
8. Viridian
9. Manganese blue hue (primary color)
10. Ultramarine blue
11. Black

Suggested Colors

The use of a wide palette—that is, a large selection of colors—can create problems for those taking their first steps in the oil medium because too many colors can be confusing. On the other hand, a very limited selection of colors can have the opposite effect.

The choice of colors we have provided here is apt for painting any subject because it is possible to obtain many other colors by mixing them together. (Note that different brands of paint may use different names for the same colors.)

Cadmium yellow Carmine Manganese blue hue

By mixing yellow and blue together you get a range of greens. If you add carmine to this you obtain neutral tones of green and brown.

The Three Primary Colors

The three primary colors are those that, when mixed together in the correct amounts, can produce all colors in nature. The three primary colors are yellow, magenta, and cyan blue. In the palette we have recommended, the three primary colors are included: cadmium yellow light, manganese blue hue, and carmine.

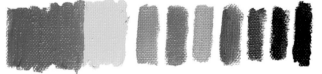

By mixing yellow and carmine together you obtain reds and oranges. If you add blue you get greens and browns.

Blue and carmine produce intense blues and violets. By adding yellow to them, you get neutral browns and greens.

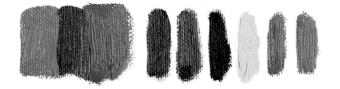

By mixing primary colors in different proportions you can obtain any color in nature. If you mix the three colors in equal parts you get black.

Complementary Colors

Complementary colors are those that, when placed next to each other, produce a maximum contrast.

The complementary color of blue is orange.

The complementary color of yellow is purple.

The complementary color of green is red.

Mixing Oil Colors

In oil painting it is essential to mix color to obtain all the colors in nature and to be able to produce a rich and personal color range.

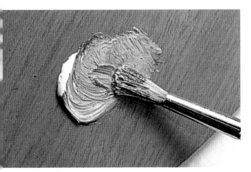

Streaky Effects.
Streaky effects are obtained by painting one color over another while allowing the parts of the underlying color to remain visible, so in certain parts there is a mix and in others there is an optical mix. In this case, yellow and viridian give us a light green.

Oil colors can be mixed in a variety of ways on the palette or on the support.

It is also possible to mix colors on the canvas, although the result is not a third uniform color. In this case, the desired color is created by an illusion of a mix, or an optical mix.

Pointillism, or Broken Color.
The accumulation of points and dots of various colors on the canvas produces an illusion of a mix. Yellow and blue suggest green.

Scrubbing.
Scrubbing is another way of obtaining an optical mix. By scrubbing the brush on an already dry color, without covering it up completely, the eye perceives the two colors as a mix. In this case, black has been scrubbed over orange to produce a brown appearance.

Glazes.
The glaze is another procedure for mixing colors on the support. This effect is a cross between a palette mix and an optical mix and commonly used in oil painting.

When mixing the paint in the palette, create a specific color before applying it over the support. This is a continuous task when painting in oil.

Fat Over Lean Process

Among the numerous possibilities of the oil painting medium is a classic painting process by which the work is constructed from several initial diluted colors, leaving the details to last. In this procedure, like any other, the artist must always respect one fundamental norm: painting fat over lean.

1 2 3 4 5 6

To paint this exercise we have used only six colors: white (1), cadmium yellow light (2), yellow ocher (3), burnt umber (4), vermilion (5), and cadmium green (6).

Painting Fat Over Lean

Painting fat over lean means never painting over a layer of paint that has more oil than the one you are going to apply on top. This rule is important because if you don't adhere to it when the colors dry the uppermost layers will eventually crack.

painted lean—that is, they must be applied with abundant turpentine. The subsequent layers are then applied with more fat to prevent cracking in the long run.

The Procedure

Because paint cracks when it dries on a fat base, the first applications of paint must be

1. The first thing to do is draw the subject on the canvas with a stick of charcoal. If you find you have to erase and start again, this shouldn't pose any problems because the charcoal lines will not be visible once the oil paint has been painted over.

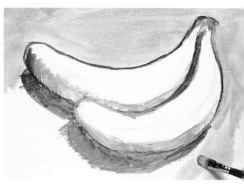

3. A mix, consisting of a touch of burnt umber and much more yellow ocher, is obtained on the palette and then turpentine is added to it. This diluted paint forms the lean base that is used to paint the background and cover up the white of the canvas, which is very bright and thus prevents the artist from painting correct tones.

2. With some burnt umber diluted in turpentine, so that it dries quickly and prevents it from dirtying the color to be applied on top, the highlights and shadows are painted in.

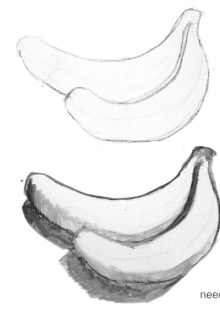

4. As the painting advances, the paint is diluted in the brush holder itself because there is no need to obtain pure color.

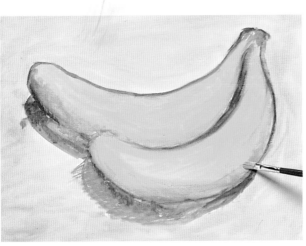

5. Now that the background is completely covered, the artist can obtain a clear picture. The bananas are painted with a slightly diluted mix of cadmium yellow light and yellow ocher for the dark areas.

6. Over the previous layer we have added light areas by first adding white.

7. Having applied the color of the bananas, the background color now appears too light, so it is darkened a little using the same paint in its natural density. The shadows cast on the table are painted with burnt umber.

9. Certain tones are reworked. In the example shown here, a touch of vermilion is worked into some tones to make them warmer.

8. All that remains is to distinguish the forms by blending the tones softly and painting the details. This is done by adding more of the same color tones over the same areas, thus achieving new tones akin to the general color of the work.

10. Note, how green has been used to paint the stem of the bananas. Furthermore, the shadows of the table have been darkened a little more and several touches of light have been applied by softly scrubbing a brush loaded with white over the brightest area of the bananas.

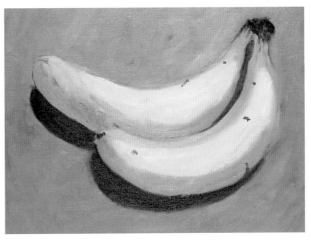

Painting on Dry

When you paint over layers of paint that have already dried, your work pace slows down because you have to wait for the paint to dry. However this technique has the advantage of allowing the artist to paint confidently with the knowledge that the colors won't dirty (or muddy) when they are applied on top.

| 1 | 2 | 3 | 4 | 5 | 6 | 7 | 8 | 9 |

To paint these flowers we have used white (1), cadmium yellow (2), vermilion (3), carmine (4), ocher (5), burnt umber (6), manganese blue hue (7), cadmium green (8), and viridian (9).

Painting on Dry

To paint on dry, it is necessary to apply the first layers of paint with plenty of turpentine so that they dry faster. Bear in mind, however, that the picture will have to be painted in more than one session. If you are in a hurry, you can use cobalt drier to speed up the drying time, although it is inadvisable to use too much of this substance because it can produce cracks in the paint (See "Solvents and Mediums for Oil Painting," pages 16–17.)

These flowers encompass a wealth of colors and the complexity that arises from this type of motif makes it a suitable exercise for learning how to paint in sessions.

1. To begin a painting process in stages, we apply a bluish gray background color, the result of a mix of manganese blue hue and a touch of burnt umber. The paint is applied with plenty of turpentine and is then left to dry.

2. The next day we draw the subject on the dried background with a stick of charcoal.

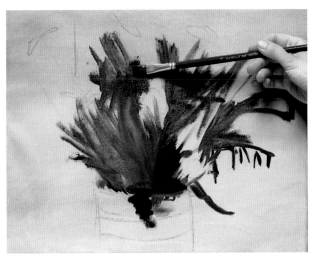

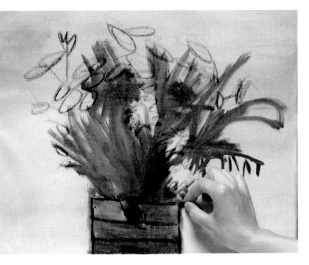

3. Viridian is used to paint the stems, which are lightened with cadmium green in certain parts and in others are darkened with burnt umber, meaning that pure color is rarely used. Note the way in which we use the brushstroke to suggest the direction of the stems.

4. Having painted the vase with pure viridian, we leave the painting to dry. Once again we draw on the now-dry support to situate forms within the space.

6. We paint the middle part of the daisies with the same but more intense tone that we used to paint each flower.

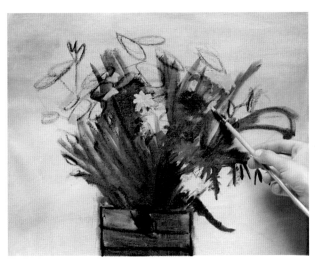

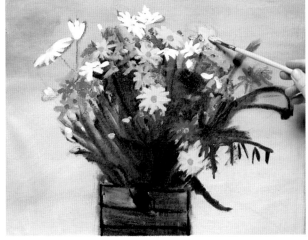

5. The flowers are painted using a different brush for each color because we will probably have to add several touches of color to the flowers that were missed the first time around.

7. To finish, we have painted the stems inside the vase and its lines and highlighted with viridian mixed with white. The shine has been painted by rubbing the brush softly over the canvas with some pure white.

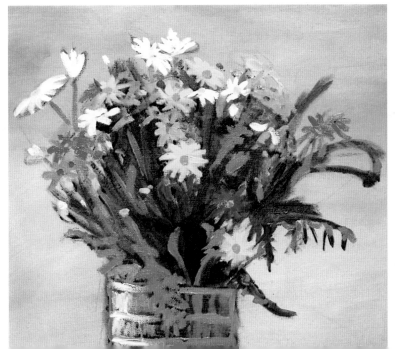

Painting on Wet, Painting Alla Prima

Painting on wet enables the artist to finish a work in a single session, without having to wait for the first layers of paint to dry. The main disadvantage of this procedure is that you can easily muddy the colors.

1 2 3 4 5 6 7 8 9

To paint this exercise we have used nine colors: white (1), cadmium yellow light (2), yellow ocher (3), burnt umber (4), vermilion (5), cadmium green (6), viridian (7), ultramarine blue (8), and black (9).

Painting *Alla Prima*

The term *alla prima* can be translated as "at the first try"—that is, starting and finishing the painting in a single session and capturing the artist's first impression of the subject, without foregoing the details. To paint in this technique it is essential to paint over the first layers of paint that are still wet.

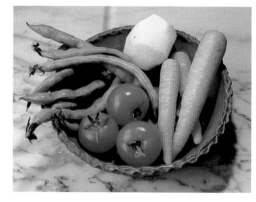

In a single session, we will paint on wet this still life, which because of the color contrast makes for a highly attractive subject.

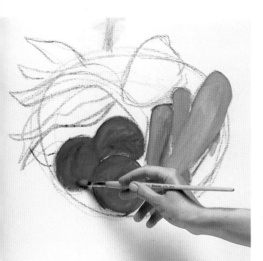

1. Having drawn the subject in charcoal, we begin to paint the carrots with vermilion mixed with cadmium yellow light, and the tomatoes with pure vermilion, bringing out the forms with washes of color.

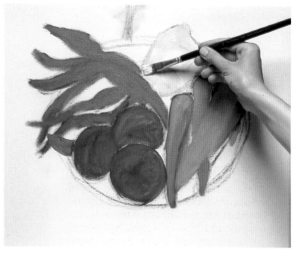

2. We continue painting the canvas in order to establish the forms within a space.

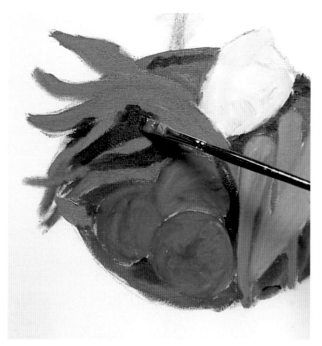

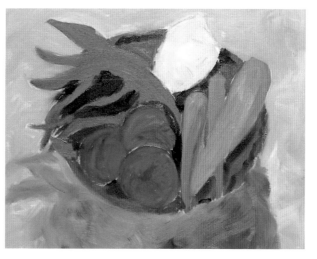

3. The color of the plate, burnt umber mixed with yellow ocher, is especially important because it will govern the intensity of the tones of the vegetables.

4. The plate is important for establishing the general color of the vegetables, but the background color is fundamental in highlighting the plate. Loose brushwork is applied in all directions to suggest the streaky effect of the marble.

6. Note how we have carried out a subtle color mix between the background color and the uppermost layer. In the potatoes, for instance, the contrast is softer and both colors blend subtly.

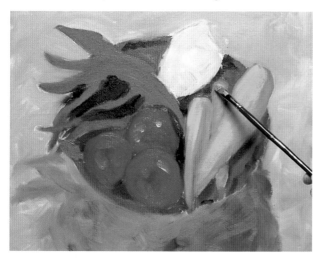

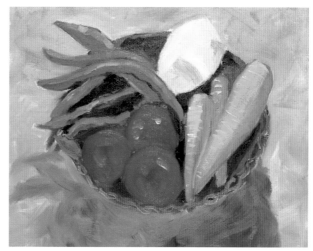

5. Once the entire surface of the canvas has been covered, we can see that, for the moment, the general tonality is correct, so we can proceed to build the masses and suggest forms. Painting on wet, we "place" the color with care, so that it doesn't mix with the background color, in places such as the shines of the tomatoes, which have been painted with white.

7. To complete the picture, the final touches of color are added, such as the stems of the beans and the tomatoes as well as the brushstrokes of light in the tomato closest to the viewer, to distance it from the one behind. In addition, we have rectified the background color, making it more intense in the shadow area achieving a greater contrast and more depth.

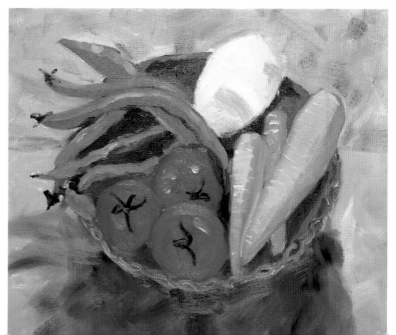

Painting with Turpentine

The main reason for painting with turpentine is to do away with the glossy characteristics of classic oil paint and obtain a more transparent result, similar to gouache or watercolor.

1 2 3 4 5 6 7 8 9

The following colors were used to paint this exercise: white (1), cadmium yellow (2), ocher (3), burnt umber (4), vermilion (5), cadmium green (6), viridian (7), ultramarine blue (8), and black (9).

Diluting Paint

Painting with turpentine allows you to eliminate the shininess of the oil medium and obtain a matte finish. In addition, the color loses consistency, gains transparency, and loses opacity.

1. A touch of turpentine is loaded on the brush.

2. The color is diluted on the palette.

Painting with Turpentine

Painting with turpentine is a good exercise for getting over the fear of painting a canvas because the paint is so diluted, it is applied quickly and is far more economical. Furthermore, when you paint with turpentine the color dries much faster, so if you are not pleased with the result you can paint over it the following day, creating a new work, or apply thicker paint on it.

3. The paint is applied with plenty of turpentine so that it is liquid and transparent.

REMEMBER

■ Because paint diluted in turpentine is runny it will probably drip and run over the canvas. This can be put to good use to create textures and special effects.

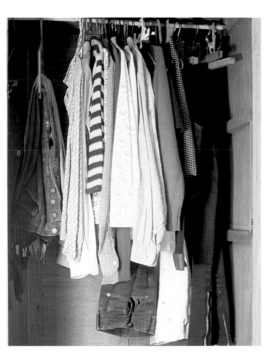

Our subject consists of an attractive household scene—a wardrobe full of clothes.

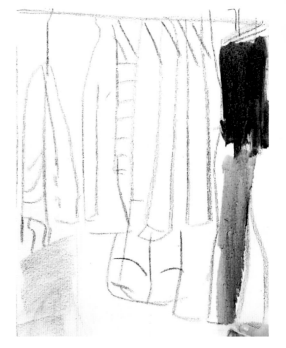

1. Once the sketch has been drawn in charcoal, we can begin applying a mix of burnt umber and black, which in its diluted form is used as a gray in certain areas.

2. All the shapes have been established with washes of color. Allowing the paint to drip downward causes a variety of densities, which create these subtle areas of the wardrobe.

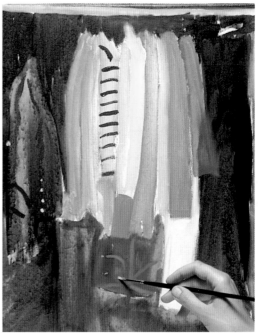

3. Because the paint dries fast, we can begin working on the details without problems.

4. All the details of the lower half, as well as the clothes hangers at the top have been painted. Next we turn our attention to the clothes.

5. To finish, we have painted the creases of the clothes with fine lines of diluted color. The background has been slightly darkened on the left-hand side and an error has been rectified: The trousers on the right had been painted too short at the start. To resolve this flaw, all we had to do is apply more color to the trousers and "stretch" the shape slightly.

Oil paint has enough consistency to be able to apply it in thick layers and mold it with a brush on the support. This procedure allows the artist to suggest textures and create relief.

1 2 3 4 5 6 7 8 9 10 11

For this exercise we have used the following colors: white (1), cadmium yellow light (2), vermilion (3), carmine (4), yellow ocher (5), burnt umber (6), manganese blue hue (7), ultramarine blue (8), cadmium green (9), viridian (10), and black (11).

Detail: Note the thickness of the applied paint the importance of the stroke in suggesting the shape, and how in the uppermost layers (the pattern of the scarf) the paint has been deposited carefully on the background so as to not dirty the color.

Our subject is a still life, with many components and a window in the background.

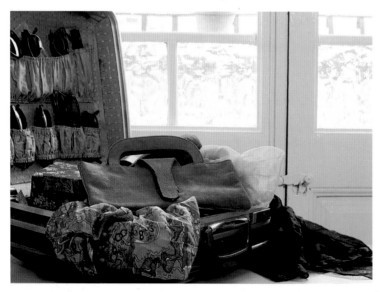

Applying Impastos

Painting with impastos is relatively easy. It all boils down to applying thick textured layers of paint with a brush. This technique is a perfect exercise for experimenting with the direction and form of the brushstroke, which is fundamental to this procedure. The only drawbacks to painting with impastos are the expense because you use a lot of paint and the difficulties posed for the beginner because such thicknesses of color can easily muddy the other colors of the painting.

Despite this, painting with impastos is highly expressive and can produce attractive results.

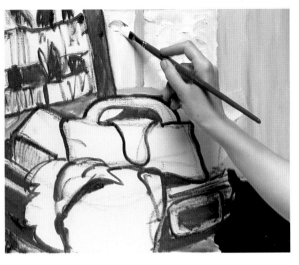

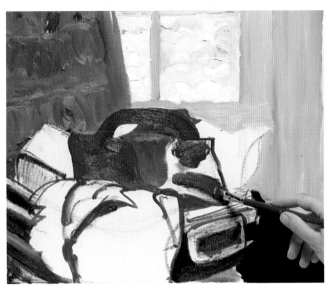

1. Having gone over the sketch executed in charcoal with a brush and diluted paint, we start work on the window with yellow ocher mixed with white. The glass is painted with a white that has been dirtied several times with the color of the window frame and blue. Note how the irregular texture of the glass is suggested with tiny semicircular brushstrokes.

2. We continue painting the canvas with thick paint to bring out the shapes with the direction and thickness of the stroke.

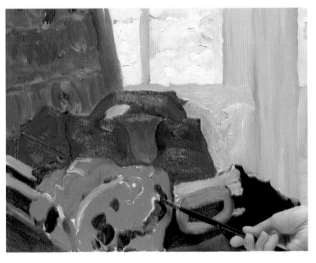

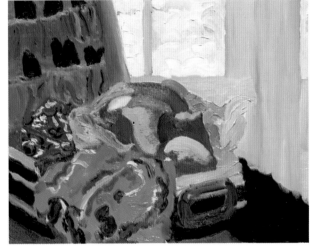

3. Having covered the entire canvas, we realize that there is a tonal error in the handbag, which is too dark. We decide to rectify the error later on, and work on the pattern of the scarf, carefully applying color. We have painted some parts of the canvas white so that the yellow appears brighter.

4. More details are added and a light tone is applied to the handbag to define it.

5. We have painted the shines on the sunglasses and the handle of the suitcase. In addition, we have started blending the light color that we applied on the handbag.

6. To add the finishing touches we work the tone of the handbag. Note in the final result how the highlights, simply fresh layers of paint, increase the depth of the painting.

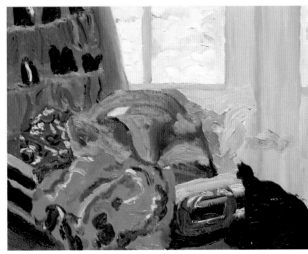

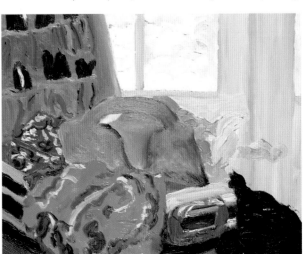

Painting with a Palette Knife

In addition to its unlimited uses, the palette knife is another painting tool that can be used to apply oil paint on the canvas and create textures.

1 2 3 4 5 6 7 8 9 10 11

For this exercise we have used the following colors: white (1), cadmium yellow medium (2), vermilion (3), carmine (4), yellow ocher (5), burnt umber (6), manganese blue hue (7), ultramarine blue (8), cadmium green (9), viridian (10), and black (11).

Painting with a Palette Knife

The palette knife can be used to apply paint on the canvas in a different way than the brush. The difference between these two tools is that the former is not as versatile as the latter because the palette knife can really only be used to create impastos. So, although it is more expensive to work with a palette knife because it uses up more paint, it is useful in understanding the versatility of oil and learning to paint with confidence because the method compels the painter to create impressions of color and not worry about details.

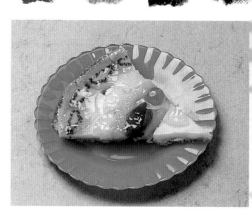

In order to complete this exercise with a palette knife, we have chosen for our subject a fruit tart with attractive colors and various textures, which are ideal for creating with a palette knife.

1. Having drawn the sketch in charcoal, we begin to paint the background by slightly texturizing with a mix of burnt umber and white.

2. We turn our attention to the plate, flattening the paint with the palette knife in order to avoid thickness, so the result is a fine layer of color.

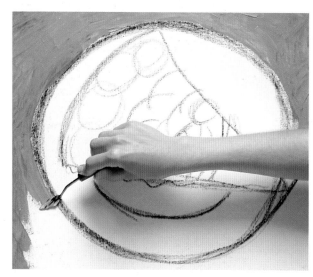

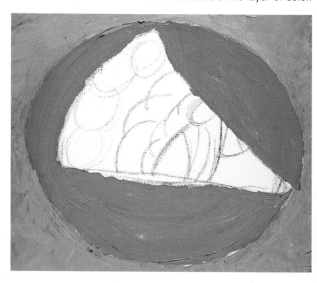

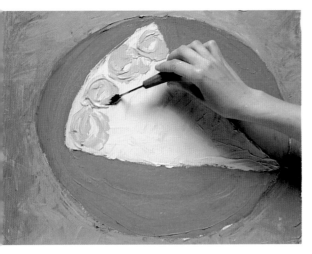

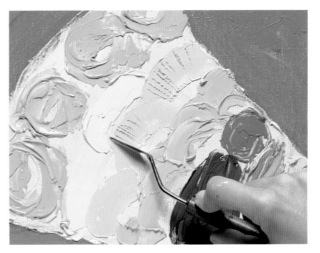

3. Having painted the base of the tart, we start applying the colors to suggest the fruit with impastos that lend themselves to the subject and create a convincing result.

4. The edge of the palette knife is ideal for creating tiny indentations in the paint. Here we use the knife to create the pineapple chunks and the segments of mandarin.

5. If you make a mistake with the palette knife, don't despair; there is no better tool for rectifying your mistakes. All that needs to be done, in this case, is to remove the paint and paint over.

6. Having painted the fruit, we paint the highlights of the plate with a softer tone. A dirty black with the remains of the colors on the palette is applied in the shadows. Note the tiny touches of black used to represent the seeds of the kiwi, placed there using the tip of the palette knife; likewise the palette knife was used to apply white to suggest shines.

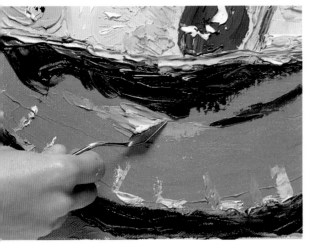

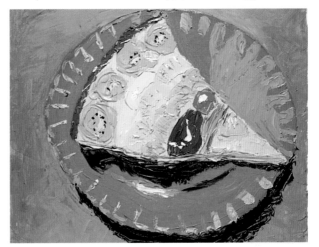

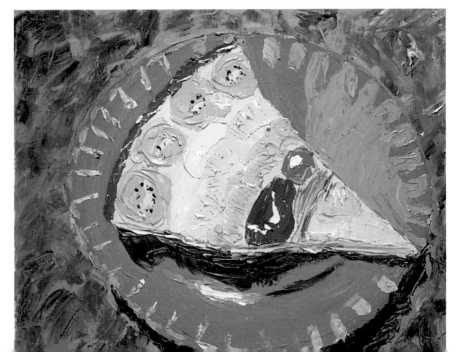

7. Finally, we paint the table with burnt umber, scrubbing with the palette knife so that the underlying color remains visible. This produces a dynamic and textured effect, which heightens the sensation of a plane separating the plate from the background.

Tricks of the Trade

In oil painting, there are a number of tricks of the trade that the artist uses to get the most out of his work. Many of them are useful for rectifying mistakes, others are suitable for creating effects.

Corrections

The versatility of oil paint allows you to rectify mistakes both on wet and dry paint. To correct on dry is obviously the easiest because it merely involves painting over layers of paint that have already dried. To correct on wet is more complicated, but it has the advantage that the artist does not have to wait for the paint to dry in order to finish it.

CORRECTING A TONE THAT IS TOO LIGHT

To correct a tone that is too light, apply a darker tone and mix it with the tone on the canvas.

1. The blue of this image is far lighter than it is supposed to be.

2. A touch of black is loaded with the same brush that was used to paint the color.

3. Now it is added on top of the image, making sure that both colors are mixed well; the intensified tone is now barely perceptible.

CORRECTING A TONE THAT IS TOO DARK

Likewise, it is possible to lighten a tone that was applied too dark by simply adding a lighter color to it.

2. Some white is loaded on the same brush that was used to paint the star. If it is done with a clean brush you will achieve an even lighter tone.

CORRECTING THE DENSITY OF THE PAINT

When you apply paint that has been over-diluted you can make it darker by applying the same tone on top but with a thicker consistency.

When the paint you have applied is too thick, you can dilute it on the support by adding turpentine. If after doing this, you wish to reduce the density of the paint even more, repeat the process after first drying the brush with a rag.

2. A little turpentine is loaded onto the same brush.

1. This star is too dark.

3. Now paint over. If you wish to obtain a streaky effect like this one, avoid covering the entire surface of the image because the more you add, the more uniform it will be.

1. The paint in this bottle is too thick and more opaque than what the artist wanted.

3. The turpentine is painted over the bottle so that the color is slightly diluted, or less dense.

REMOVING AN ELEMENT

If you make an important color error or there is an element of the picture that has been badly resolved and can only be corrected by starting over, the only remedy is to remove the paint with the palette knife and repaint it.

1. The pink flag has been included by mistake, and we have decided to remove it.

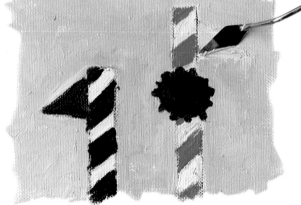

2. With the palette knife remove the paint.

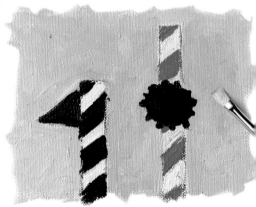

3. Now paint over the background and achieve a perfect result, as if the pink flag had never existed.

CORRECTING WITH A CLEAN BRUSH

Sometimes we make small errors that can be corrected with almost any painting tool on hand: our fingers, a rag, or even a clean brush.

1. Here the hair of the brush went beyond the shape.

2. With a clean brush remove the paint from the contour of the bottle and perfect the outline.

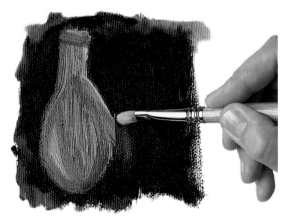

3. Add a few strokes of color to the background to finalize the procedure.

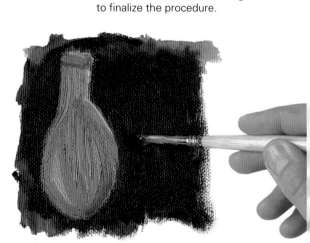

CORRECTING A TONE ON DRY

After you've finished a painting and allowed it to dry, you may feel that some of the colors are too intense and that some or all of the subjects' tones require toning down. How do we resolve this problem?

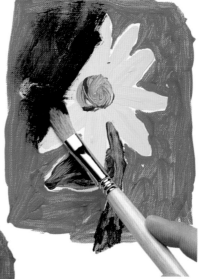

1. Paint the color over the dry surface. Black is the darkest color so we can use medium tones like yellow ocher or certain blues.

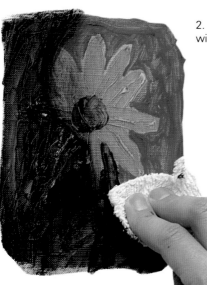

2. Remove the excess color with a rag.

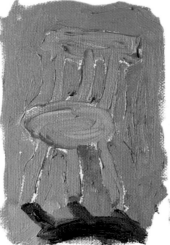

3. This tones the colors and reduces their intensity. The trick can also be used to create atmosphere or suggest distance or objects behind a curtain.

Effects

Certain tricks of the trade can be used to make corrections, although they are usually used to create effects and manipulate the color.

BLOTTING

The first layers of paint should always be applied half-diluted, but if you haven't done this and want to paint a second layer—and the first one has formed a thick impasto that will dirty your color—you can do the following:

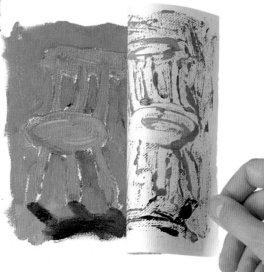

1. The first layer of paint is too thick and some of it needs to be removed.

2. Place a sheet of newspaper over the surface. Then press down lightly, being careful not to move it.

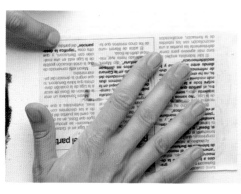

3. Peel the paper off. Note how much of the paint it has absorbed and how the relief has been flattened.

MASKING

To paint straight parts of elements, such as the frame of a window or difficult angles, you can use masking tape to preserve the white of the canvas.

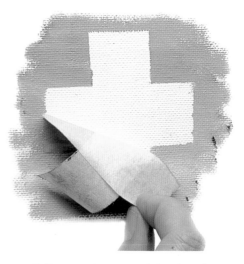

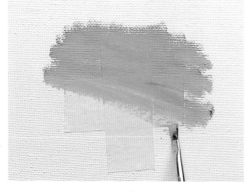

1. Apply tape to the canvas in a way that conceals the shape you want to retain. Then paint over the area.

2. Remove the tape and the shape is perfectly masked.

SGRAFFITO

The sgraffito technique is used to create effects by scratching the surface of the painting with the brush handle or with the palette knife.

1. Apply a layer of color; if it is done over another color as it is in this case, the result will be even more attractive.

2. Using the tip of the palette knife, draw over the wet paint to open up lines revealing the underlying color.

3. In this way you can draw an image. This technique can be used to suggest anything from the slates of a rooftop to elements in the distance.

SCRUBBING

Scrubbing is a common technique in oil painting and is used to produce subtle effects, create optical mixes, and correct tones.

1. Dip the brush in a color, vermilion in this case.

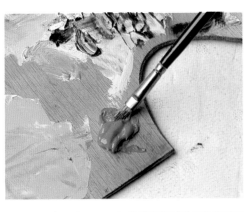

2. Remove the excess paint by applying it on a piece of paper.

3. Softly scrub the surface by making circular movements with the bristles.

4. The result is similar to a glaze that can be used to suggest a rugged texture or a misty afternoon atmosphere. Note the optical effect of the vermilion over the yellow that creates an orange.

Painting with . . .

You can use virtually any object to apply paint to the canvas. The different traces and marks that objects give are extremely interesting for creating and suggesting textures.

SPONGE

1. Pick up some color.

2. Apply it to the support. The sponge produces an uneven track that is ideal for painting the foam of water or certain types of vegetation.

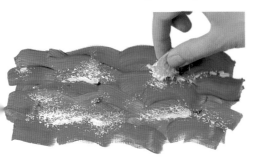

SPOON

This texture, apt for painting a country path or the bark of a tree, is obtained by lightly pressing down on a spoon.

TUBE

The paint tube itself provides an unsuspected tool for applying color to the canvas because it produces circular marks in the form of tiny points.

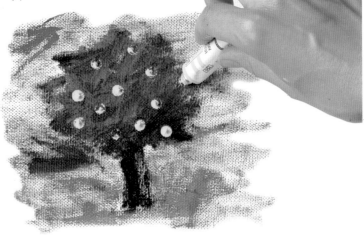

Skies

Skies appear so prominently in paintings that the light and clouds in them end up having a profound effect over the entire picture.

1 2 3 4 5 6

We have used six colors to paint this sky: white (1), cadmium yellow light (2), manganese blue hue (3), ultramarine blue (4), burnt umber (5), and black (6).

Painting a Sky

The beginner can paint a cloudless sky without having to do anything else other than paint a color gradation down to the horizon line. The presence of clouds, however, is an entirely different matter because the artist has to convey these fluffy bodies and recreate their forms.

Although this sky may appear easy to paint, it does entail certain complexities. Therefore, it needs to be executed with exactness and confidence because, together with the land, the sky is the "cohost" of the painting.

1. Having drawn the shape of the clouds with charcoal, we first paint the sky with ultramarine blue slightly broken with burnt umber. The tone should be diluted and grayer as we approach the horizon line.

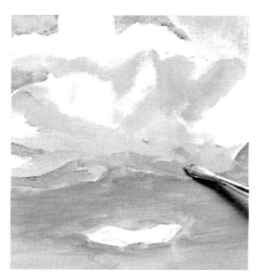

2. Make some gray by mixing white and black with the remains of blue that are left on the palette. Remember white gets dirty easily, so be prudent with the proportions so you do not waste any. Use the tone to paint the darker areas of the clouds.

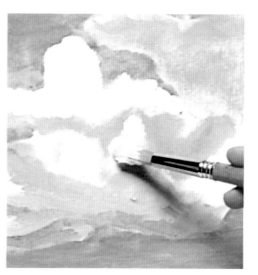

3. Now paint the lightest parts of the clouds with pure white.

4. Once the entire cloud has been covered in paint we can blend the tones subtly with the brush.

5. Here we have applied a touch of white mixed with yellow to warm the brightest parts of the cloud. We blend the colors with our finger to obtain a fluffier effect.

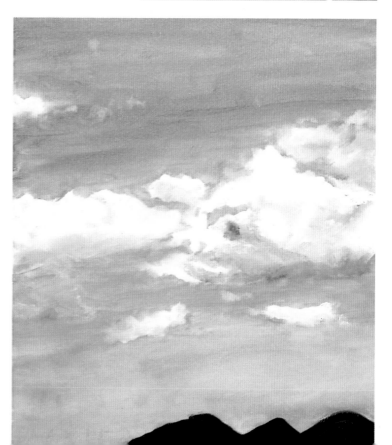

6. Lastly, the land is painted, providing a contrasting color with that of the sky. We have given the clouds a billowing and vaporescent look by spreading the color with our finger past the clouds and onto the blue sky.

Water

The nature of water is capricious and ever-changing because it is a liquid and the slightest movement alters its surface. It does not have a specific color, so its tones change with the light. No matter how difficult water is as a theme, it can be made easy in oil painting, because a successful painting of water depends only on practice and method.

1 2 3 4 5

Five colors have been used to paint this beautiful cove: white (1), manganese blue hue (2), ultramarine blue (2), viridian (4), and burnt umber (5).

Painting Water

When you observe the great mass of the sea it becomes immediately evident that it does not have a uniform color but changes according to its depth and the amount of seaweed under the surface and that the light creates reflections on its surface. So it is essential to paint a few sketches before attempting to paint it from nature. This will allow you to practice capturing the initial impression rapidly, which you can then paint at a slower pace.

Paint the crystal clear water of this cove and capture the changes in color as it distances itself from the shore.

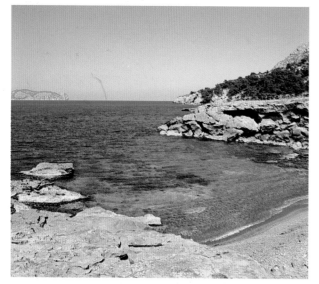

1. Having drawn the sketch in charcoal, go over the forms with a brush of semi-diluted viridian and burnt umber.

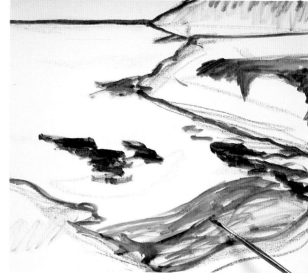

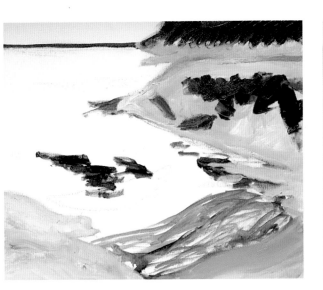

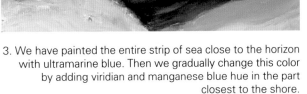

2. Paint the background, even if it only consists of a series of blobs, before starting on the water because this will allow you to evaluate the intensity of the blues.

3. We have painted the entire strip of sea close to the horizon with ultramarine blue. Then we gradually change this color by adding viridian and manganese blue hue in the part closest to the shore.

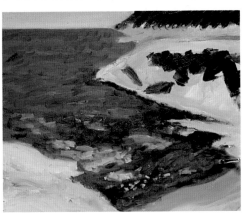

4. With a white mixed with a touch of light ocher, we paint the land and begin to define the lighter parts of the bottom that can be seen through the water. Note how we apply small patches of color to suggest the tiny ripples on the surface.

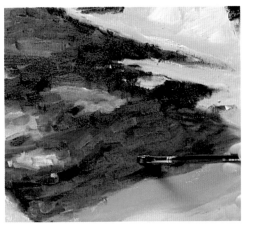

5. With burnt umber mixed with viridian, paint the darkest parts of the water, simulating its texture with tiny specks that convey the idea of its wavy surface.

6. We turn our attention once again to the light tones, allowing the white to mix slightly with the color of the bottom.

8. In the finished painting, you can see how the land has only been suggested with a few patches of color; the wet sand, has been painted with a darker tone than the rest, and the rocks have been created with light dabs of color.

7. To finish, add a line of pure white to mark the foam, the brightest white of the picture, applying it carefully so as not to dirty it.

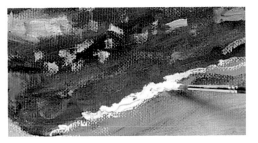

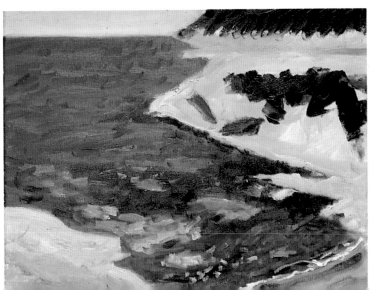

Vegetation

Vegetation has a wide diversity of shapes, textures, and tones, so each part of a landscape requires a different treatment.

For our subject, we have chosen a field with several trees in the background.

We have used five colors to paint the vegetation of this simple landscape: cadmium yellow (1), cadmium green (2), viridian (3), ocher (4), and burnt umber (5).

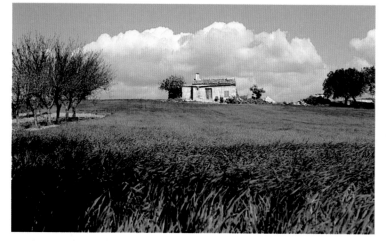

Painting Vegetation

There is a traditional procedure for painting a landscape in oil. This consists of covering the canvas with a series of washes and then working on the masses and details. From the outset, it is important to bear in mind that, although a landscape may appear to be a homogenous mass of green, closer inspection reveals that there is an infinite number of different tones and hues.

1. Having gone over the original shapes drawn in charcoal with a brush of half-diluted burnt umber to establish the areas of light and shadow, we have painted the field with cadmium green toned with yellow ocher. The brushwork suggests the direction of the grass and the blades in the foreground.

2. The trees in the background are painted with a base color of viridian, which we are going to darken slightly, depending on their distance, with burnt umber.

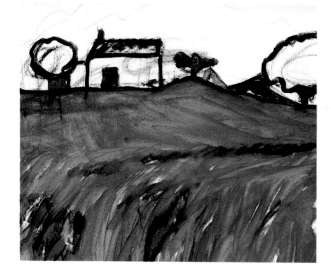

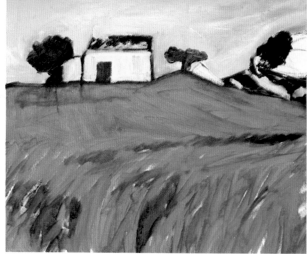

3. To indicate the dark areas among the blades of grass, we scrub the top layer with a brush loaded with the same green used to paint the trees.

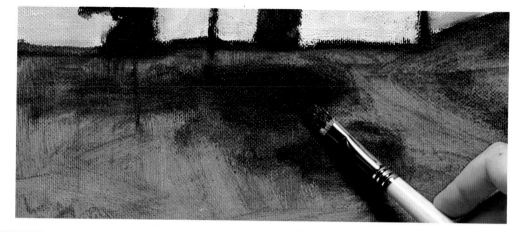

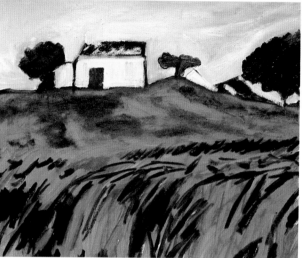

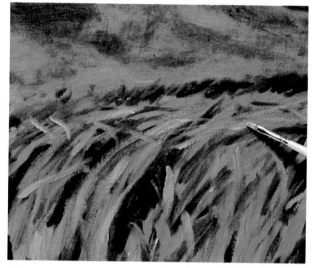

4. The grass in the foreground is suggested with strokes of viridian darkened with burnt umber, indicating the direction and shape of the blades.

5. The lighter blades of grass are painted with cadmium green mixed with cadmium yellow light.

6. The blossom on the tree next to the house can be painted using a sponge, which is ideal for obtaining this special texture.

7. To finish up, paint the flowers in the grass with dabs of pure yellow, a warm, light color that brings the foreground closer to the spectator and heightens the sensation of depth within the work as a whole.

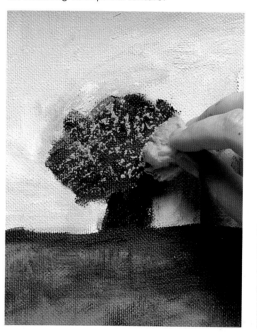

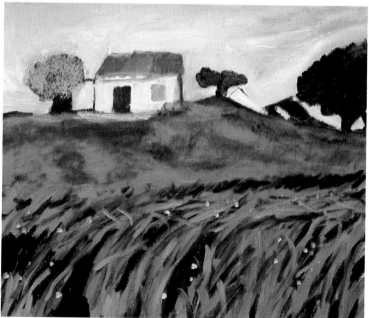

Flesh Colors

The color of human flesh may be a mystery for someone who has never attempted to paint it because it has so many hues and tones. For the beginner, painting the human figure in oil is a challenge that pays off by revealing many secrets of the medium.

1 2 3 4 5 6 7

Painting Skin

There is no such thing as a specific range of colors for painting human skin because individuals have their own particular tones. Therefore, to obtain tones that suggest human flesh, the artist has to create colors through mixes.

The following colors have been used to paint this model: white (1), cadmium yellow (2), vermilion (3), carmine (4), yellow ocher (5), burnt umber (6), and ultramarine blue (7).

1. Having drawn the model with charcoal, the sketch is gone over to define the shadows with violet, obtained by mixing a very diluted carmine with ultramarine blue.

We will use this female bust as our subject for painting the subtle qualities of human flesh.

2. To begin applying color, the entire body is covered with a lightly diluted tone obtained from a mix of white, yellow, and a touch of vermilion.

3. The darkest tones are painted with a mix of carmine, ultramarine blue, burnt umber, and a hint of white. To paint the line between the ribs we use orange.

4. Having painted the light areas with a mixture of the background mix and a little yellow, we blend the tones by rubbing softly with the brush.

5. Certain shadows have been accentuated and the nipples have been painted; the dividing line between the ribs is softened with our finger.

6. Certain shadows are worked further still by darkening them, and several touches of light with pure white are added, which causes the color of the background to fade slightly.

7. Note the difference once the green background has been added. The body appears more three-dimensional. This is because the original background was white and did not create any contrast with the torso, which had been painted with predominately warm colors. By painting a cool green background, the contrast heightens the sensation of space because the body appears to approach the spectator.